Anno Frank Leven
Born in 1948

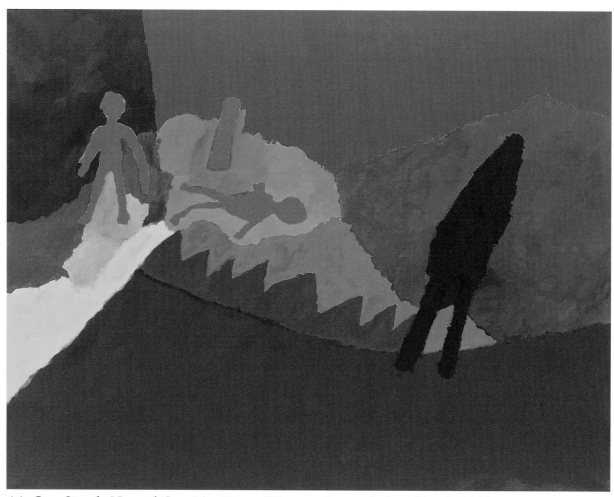

16. *One Stands Up and One Lies Down* (Einer steht und einer liegt), 1992

R.S. JOHNSON FINE ART • 645 N. MICHIGAN AVENUE
CHICAGO, ILLINOIS 60611• (312) 943-1661

Anno Frank Leven

THE NEW GERMAN PAINTING
and
ANNO FRANK LEVEN

Essay by R. Stanley Johnson

DECEMBER 1993

ISBN 0-9628903-5-9
Library of Congress Catalogue Card No. 93-086915
Text copyright © by R. Stanley Johnson
Illustrations copyright © by R. Stanley Johnson
Printed by Ries Graphics, U.S.A.
Published: Fall, 1993

A special thanks to
Ursula Maria Johnson and Geraldine Anne Johnson
for their ideas and suggestions.

On Cover

Cat. No. 2 Four Trees at the Village Pond, 1988
(Vier Bäume am Dorfweiher)
Oil on canvas
39 1/2 x 51 1/2 inches

The New German Painting
and
Anno Frank Leven

A number of Germany's leading contemporary artists have stated that they are the first post-war generation whose art was no longer overwhelmed by the moral dilemmas of a National Socialist heritage and by the traumas remaining from the East-West division of their country. In apparent contradiction to this, there are Anselm Kiefer's charred landscapes, Markus Lüpertz's 1960s and 1970s paintings filled with army helmets and uniforms and Jörg Immendorff's contemporary statements about totalitarianism and the arrogance of political power. It is true that in confronting directly and openly such reminders of Germany's legacy and such previously taboo subjects, these artists in their various ways have attempted to face up to the continuing reality of that past. It also is true that when symbols of these moral dilemmas and traumas are used artistically, they often now represent only vestiges of a past legacy and usually no longer retain their original meanings.[1] Finally, artists such as Baselitz, Immendorff, Kiefer, Lüpertz, Penck, Richter, Hödicke and Polke were not the first twentieth-century German artists who to one degree or another have worked under the shadow of a dark history. Art in Germany since World War I has been constantly subject to political and social realities which often have seriously affected the individual artists. [2]

Post-war German artists have had still other unique problems. One of these was the lack of a clearly defined cultural center such as Paris for France and French artists. Germany's artistic center is still fragmented among disparate movements and philosophies found in Berlin, Düsseldorf, Cologne and other cities in the West as well as within the former East

1. See: Jack Cowart *Expressions: New Art from Germany*, St. Louis Art Museum and Prestel Verlag, Munich, 1983: page 17.
2. See: Joseph Thompson "Fates of the Figure in Postwar German Painting": in *Refigured Painting: The German Image 1960-1988*, Guggenheim Foundation, New York and Prestel Verlag, Munich, 1989, p.32.

Germany. Even more marking were the political and social differences between the two Germanys. The Germans themselves did not realize the depth and nature of these divisions until after reunification. These differences were particularly evident in their two distinct artistic visions. Using Soviet models and Soviet dictates, art expression in the East was dominated by a "socialist realism". In West Germany, art appeared as a tamed version of non-objective abstraction, "tamed" in that this art was not truly abstract in the sense that Jackson Pollock's abstractions poured forth as the ultimate expression of that artist's creativity. Earlier German abstraction was based more on a desire to avoid "real" subjects which in any way could have reminded their viewers of Germany's immediate past. In both the East's socialist realism and the West's forms of abstract modes, the art produced was dependent on "official" or current styles which largely shut off artists from their cultural heritage. These limiting ground rules allowed artists little possibility for individual expression. [3]

In the 1960s and 1970s, this same East-West confrontation provided much of the inspiration for New German Art which finally burst upon the international scene in the 1980s. Looking back at the remarkable 1983 St. Louis Museum exhibit on contemporary German art[4] and considering those artists chosen to illustrate this criss-crossing East-West development, it is interesting to note that three of the five representative artists were born in the East and another grew up on the East-West border. Three of these artists (Baselitz, Lüpertz, and Penck) were in Berlin while Immendorff and later Kiefer were students of Joseph Beuys in Düsseldorf. Wherever they worked, East-West political, social and cultural confrontations permeated the work of all these artists. For example, A.R. Penck, who arrived in the West in 1980, was faced with the dual artistic objectives of continuing his exploration of East-West themes while at the same time developing an art form which would be compatible with the new social and political system to which he had moved. The intensity and preoccupations of such confrontations made it difficult for Germany's younger artists to ignore the very immediate social and political realities in order to turn their attention to Conceptualism and Minimalism, then the world's art movements most in view. By not taking part in these latter movements in the 1960s and 1970s,[5] however, German artists were considered "provincial" and they remained on the fringes of the larger art scene. Another reason that international art criticism relegated German artistic developments in these decades to a "provincial" and minor role was that German artists seemed to be promulgating a derivative and mimetic Expressionism inspired by early twentieth-century Expressionists such as Kirchner and Nolde. This early Expressionism, however, consisted of both a "realist stream" and those more abstract directions which eventually developed into non-objective art. In calling these young German artists

3. See: Siegfried Gohr "The Difficulties of German Painting with its Own Traditon" in *Expressions: New Art from Germany*, St. Louis Art Museum and Prestel Verlag, Munich, 1983, p. 27.
4. *Expressions: New Art in Germany: Georg Baselitz, Jorg Immendorff, Anselm Kiefer, Markus Lupertz, A.R. Penck* St. Louis Art Museum, 1983.
5. To the contrary of German-speaking Swiss artists such as Max Bill and Richard Lohse.

"expressionists", in the sense of being merely realists, art criticism ignored Expressionism's influence on later abstract art and thus took from historic Expressionism at least half of its future developments.[6] Critics also were incorrect in considering the New German Art's more representative treatments of the human figure as somehow tainted with a National Socialist past and more abstract treatments as somehow prescient of the future. In more general terms, much criticism of the New German Art has tried to force this art too simply into either realist-abstract or abstract- expressionist modes. The complexity and variety of the works produced cannot allow such neat divisions to be thrust upon the artists in question.

The scholarly debates on these various issues, which have also extended beyond German art to include the analysis of late twentieth-century art in general, are crystallized in the often conflicting writings of Benjamin Buchloh and Donald B. Kuspit. Buchloh, who believes in the continuing and lasting dominance of conceptual and minimalist art, condemned recent German art as being too traditional to be of any great significance,[7] while Kuspit considered the New German Art as being on the contrary "a true home for radical art today".[8] Underlying these arguments is the larger issue of whether the "end of painting" might have arrived as hypothesized, for example, in Douglas Crimp's major essay in 1981.[9] These discussions are also related to a slightly later article by Thomas Lawson who groups together German, Italian and American "pseudo-expressionists" such as Jonathan Borofsky, Sandro Chia, Francesco Clemente, Enzo Cucchi, Rainer Fetting, Luciano Castelli, Salomé and Julian Schnabel whom he sees as "part of the last, decadent flowering of the modernist spirit".[10] According to Lawson, these artists try to make paintings look "fresh, but not too alienating, so they take recognizable styles and make them over, on a larger scale, with brighter color and more pizzazz. Their work may

6. See: Siegfreid Gohr "The Difficulties of German Painting with its Own Tradition" in *Expressions: New Art From Germany*, St. Louis Art Museum and Prestel Verlag, Munich, 1983, p. 31.
7. See: Benjamin H.D. Buchloh "Figures of Authority, Ciphers of Regression: Notes on the Return of Representation in European Painting" in *October*, no. 16 (Spring, 1981): p. 55
8. See: Donald B. Kuspit "The American Case Against Current German Painting" in *Expressions: New Art from Germany*, St. Louis Art Museum, 1983: p. 55.
9. Douglas Crimp "The End of Painting", *October* no. 16 (Spring, 1981). pp. 69, 71, and 72. As an example of this "end", Crimp cites Frenchman Daniel Buren's interminably repeated striped panels which mean nothing, do not attempt to mean something, are not meant to be seen by anyone and have no purpose or function. Their subject is "nothingness" but they end up themselves becoming "nothing". The only place for this "it" is in a museum where, according to Buren: "...Ideally the work of art finds itself not just screened from the world, but shut up in a safe, permanently and totally, sheltered from the eye..." Crimp finds apparent support for his ideas from none other than William Rubin then the director of the New York Museum of Modern Art's Department of Painting and Sculpture who in a 1974 issue of *Artforum* stated that: "...Perhaps, looking back 10, 15, 30 years from now, it will appear that the modernist tradition really did come to an end within the last few years...If so, historians a century from now... will see it beginning shortly after the middle of the 19th century and ending in the 1960's..."
10. Thomas Lawson "Last Exit: Painting" in *Art Forum*, October, 1981.

look brash and simple, but it is meant to be and it is altogether too calculated to be as anarchistic as they pretend." From this group Lawson is particularly severe concerning the "cultural canabalism" of Clemente and Schnabel who have picked up on "the neoromantic, pseudosurreal aspects of fashionable French and Italian art of the '30s and '40s and make a great fuss about their wickedly outrageous taste." For Lawson, these two artists make use of "an uncontrolled annexation of material...a torrent of stuff that is supposedly poetic, and thus removed from mere criticism."[11]

In the disputes on theory between Buchloh and Kuspit, Buchloh, broadening his attack even further than Lawson but concentrating specifically on the paintings of the "post-modern" Germans, saw this latter art as a form of "reactionary authoritarianism" which represented not only a return to the "decadent style" of expressionism, already thoroughly developed at the beginning of the century, but also a return to painting as such. For Buchloh, "painting" should be considered "an obsolete convention" (hence the "end of painting") after the development of Modernism in its varied forms including in part American Minimalism and Conceptualism and the *Informel* in France. Buchloh believed that the only apparent originality of the post-modern German painters consisted in their "current historical [sic] availability" rather than in any true innovation. For Buchloh, the most negative aspect about these post-modern artists was their return to "the perceptual conventions of mimetic representation", to forms of art which apparently lacked any epistemological understanding of the historical significance of the preceding movement of Modernism.[12] Buchloh's concept of German Post-Modernism is quite similar to Lawson's description of American Post-Modernism as: "...a nostalgic desire to recover an undifferentiated past...Any art that appropriates styles and imagery from other epochs, other cultures, qualifies as 'post-modern'..."[13] and in these respects therefore would not be truly creative.

By the time of his 1983 writings, Kuspit concluded that the Modernism defended by Buchloh had become an over-used "stereotype of itself" and that Buchloh did not understand that this new German painting was in no way "mimetic". On the contrary, Kuspit saw this painting's main objective as wanting to create a "fictional reference of which the figure is the instrument, to create an illusion of being-natural".[14] That is to say rather than being "mimetic" or pretending to be "real" in that sense, this painting intended instead to establish a kind of "artificial natural expression" whose true objective was to expose "the artificiality and abstractness of all expression". Such a concept would make the New German Art a truly new movement following "Modernism" and not, as Buchloh would have it, just one of an unending series of differentiated, dialectical responses to an

11. See again: Thomas Lawson "Last Exit: Painting" in *Art Forum*, October 1981.
12. See: Donald B. Kuspit "The American Case Against Current German Painting" in *Expressions: New Art from Germany*, St. Louis Art Museum, 1983; pp. 43-44.
13. Thomas Lawson "Last Exit: Painting" in *Art Forum*, October, 1981.
14. See: Donald B. Kuspit "The American Case Against Current German Painting" in *Expressions: New Art from Germany*, St. Louis Art Museum, 1983; pp. 43-44.

abstract "Modernism", each response ultimately doomed to failure. On the other hand, if Kuspit was correct in calling the New German Painting the new "true home for radical art today,"[15] then Buchloh no longer would be on the high ground of "radicalism" but would have become himself the "traditionialist".[16]

In these various discussions, there is a question of exactly what was meant by "the end of painting" and whether this referred to the real "end of the art of painting" or only to the end of the "idea" of a ceaselessly innovative modern art. Octavio Paz has linked this distinction with the concept of negation:

> Today...modern art is beginning to lose its power of negation...Negation is no longer creative. I am not saying that we are living the end of art: we are living the end of the idea of modern art.[17]

A decade has followed these initial scholarly debates. Despite the unending attacks against its originality, the New German Painting has shown extraordinary staying power while the "Modernism" of the 1960s and 1970s has taken its place as an influential but now superceded movement in the history of art, which many contemporary critics and much of the public see as having been relatively limited in time and scope. In fact, recent attempts at revival notwithstanding, most of the "modernist" experiments which characterized the art of the 60s began to lose their vitality by the 70s - the demonstration of art theory, as a subject of art, not being exploitable indefinitely. On the other hand, Buchloh's notion of post-modernism as an unending series of dialectical responses to "the end of painting" also has had staying power and is still a key factor in understanding the present art scene in Germany.

<p style="text-align:center">* * *</p>

Anno Frank Leven, artist and poet, was born in Krefeld in the Rhineland in 1948. This

15. See: Donald B. Kuspit "The American Case Against Current German Painting" in *Expressions: New Art from Germany*, St. Louis Art Museum 1983: p.55 where the complete text including this statement reads as follows:

 > I saw them as an exploration of traditional identities accepted as authentic, with the artist like a sand crab, trying to live in an alien shell in the hope that he or she might gain an understanding of what a home might be (while knowing that they can never actually have their own by the terms of the modern condition). With this understanding came the recognition that the new German expressionism is a true home for radical art today.

16. One of the auxiliary problems of the Buchloh-Kuspit differences is that each critic judged artists as being "good" or "bad" depending not on the aesthetics involved but rather on which side of their discussions of theory each artist fell.

17. Octavio Paz, from: *Children of the Mire: Modern Poetry from Romanticism to the Avant-Garde*. See also: Claudia Hart *Herbst Salon* "Rollenspiele für eine neue Weltordnung"("Role Playing in a New World Order"), in *art*, October, 1993, p. 70 with reference to Hart's own painting "In memory of: The Death of Painting". See also: Jürg Altwegg "Das Ende der Revolution und der Avantgarden" ("The End of Revolution and of the Avant-Garde") in: *Binationale*, Düsseldorf, 1988: pp. 29-41.

was sixteen years after the birth of Richter, ten years after that of Baselitz and Hödicke, nine years after Penck, seven years after Lüpertz and only three years after Immendorff and Kiefer. Leven was a student at Düsseldorf's Kunstakademie. It was this same Kunstakademie where Richter had studied with the abstract expressionist Götz, where Immendorff and Kiefer had been students of Beuys and where Lüpertz presently is a professor. This also is the same Kunstakademie where Paul Klee once had taught and where Joseph Beuys, enrolled as a student under Ewald Mataré in 1944, later became the most influential art teacher in Germany and one of the twentieth-century's most highly recognized artists.

For Anno Frank Leven and his generation, the personality of Joseph Beuys, who died in 1988, is still very present in the halls of Düsseldorf's Kunstakademie. A significant moment in Beuys' career came in about 1960 when he became the center of the controversy about *Fluxus*.[18] *Fluxus* attempted to bring together all types of artists "into an anti-egocentric, anti-nationalistic and anonymous platform".[19] New German Painting was particularly interested in *Fluxus'* aim of eliminating frontiers and in releasing the individual from any type of physical, intellectual or political repression. The *Fluxus* movement also believed that "art is life". Since it is clear that art did not replicate life but was only a fiction of life, traditional painting according to Beuys would have to be abandoned since painting's apparent stated objective was not achievable. Beuys was joined later by critics such as Buchloh and others who used these ideas to affirm that "the end of painting" had arrived. Beuys himself would often stop in front of his students' canvases and inquire with a faintly ironic smile: "Well, still painting, are we?" From Beuys' standpoint, painting with oil on canvas was no longer a serious or even an acceptable medium for art.[20]

Anno Frank Leven and other younger artists of his generation, though fascinated by Beuys' personality and concepts of artistic freedom, nevertheless rejected Beuys' primary themes and in their art have turned in other directions. For Leven, unlike slightly older artists Baselitz, Kiefer, Lüpertz and others, Germany's National Socialist past is no more of a presence and an influence than for an artist painting on another Continent. In the quietness and utter sparseness of Leven's studio, past and present East-West problems seem to be equally as far away. It is not that Leven is uninterested in social or political

18. *Fluxus* (coming from the Heraclitean concept of "panta rei": into the same river we both step and do not step-we both are and are not) was a sort of extension of an American "Happening" except that the audience's participation in a "Happening" was not encouraged to take place in *Fluxus*. *Fluxus*, a movement rivaling the Dadaism of Marcel Duchamp, was more concerned with energy and artistic activity and less with the final work of art.
19. Démosthenes Davvetas "Joseph Beuys-Man is Sculpture" in *German Art Now*, London and New York, 1989: pp. 15-16.
20. Heinrich Klotz "Abstraction and Fiction" in *Refigured Painting: The German Image 1960-1988*, Guggenheim Foundation, New York and Prestel Verlag, Munich, 1989: pp. 51-52

questions, it is simply that they do not concern or intrude upon his painting. Leven creates his art unaffected by exterior events and completely self-referentially. Being a "public figure" in the Beuys tradition also does not correspond to Leven. He would have the same negative, bemused reaction as most passers-by in Bonn seeing a sculpture being recently executed in public by Markus Lüpertz - a Lüpertz dressed in "a black watch cap, a black T-shirt, a black quilted vest, loose-fitting jeans, and white Converse All-Star sneakers"[21] and with his Rolls-Royce convertible conveniently parked off to the side. Leven, instead of wearing "a black quilted vest", more likely would be dressed quite simply. Rather than in creating paintings in a public square with all the accompanying pre-arranged publicity, Leven more likely might be found wandering off for weeks by himself in search of total solitude in the nearby forests. Solitude is important for Leven who once lived alone for months as a hermit in the countryside near Pian di Melosa in Toscana. Leven also has a youthful enthusiasm and naiveté which he has retained in spite of his knowledge and awareness of history (he is Jesuit educated) and in spite of the personal experience of a life threatening illness overcome. There is in Leven a continual sense of wonderment and unhurried leisureliness of someone totally free from material possessiveness. With Leven, there is a feeling of personal abandon, an abandon which recalls Dubuffet and Picasso. Leven has withdrawn from struggling with life's daily "realities" but has not therefore fallen into a romantic isolation or a zen mysticism. The world for him is a sort of unending "happening", all generated from within himself. These varied sentiments are often reflected in Leven's paintings.

Anno Frank Leven, because of his quiet, shy and modest ways, might first appear as an isolated artist following his own solitary paths. It is perhaps surprising therefore to see to what extent his art and style correspond to or interact with many of the newest directions of contemporary culture. For example, the late twentieth-century is a time of increasing wariness of the artist who, like Lüpertz and contrary to Leven, adopts a self-consciously public and flamboyant personality. These also are times which no longer particularly look for an artist to espouse the "traditional" development from a subject-oriented art to pure abstraction. In this respect, Leven again is not alone. Baselitz, for example, leaves it to his viewers to overcome the disorienting effects of images depicted upside-down in order to allow a subject-based abstraction to emerge from the process of perception itself. Leven, like Immendorff (e.g. *Café Deutschland* series) and Lüpertz, makes use of actual objects - café scenes, a fair, roof tiles, tree trunks, mountainous landscapes, shop windows, table tops - which can seem to emerge and sometimes (in the same picture) are so illegible as to be unrecognizable and verging on complete abstraction. These are almost pure forms, while always remaining real objects. By de-emphasizing content, Leven allows his images to be situated on the very threshold of objective representation. Leven's viewers have to understand and appreciate more than the beauty of the "pure forms" of non-objective compositions. They must also recognize in an appar-

21. See: Ferdinand Protzman "Markus Lupertz: The Doubting Dandy" in *Art News*, New York, Oct. 1993, p. 124.

ently abstract painting an object- related configuration. Leven's art is in no way a retreat to pre-abstract modes but is an advance to narrative painting by way of abstraction.[22] Leven, like Baselitz, Richter, Immendorff, Polke, Lüpertz and Penck, has developed very personal solutions as to how painting can continue after its earlier apparent "end" in total abstraction.

Anno Frank Leven's art reflects a return to certain " classical values". The sixty-two year-old German artist Gotthard Graubner recently spoke of such values: "One must reflect on classical values again, in painting as in society as a whole. That will perhaps be the next avant-garde". Graubner goes on to say that: "There is a feeling of exhaustion in the art scene - everything has been tried and tried again - and yet younger artists feel compelled to be innovative. In a sense, they are the real reactionaries"[23]. Many would agree with this idea including Barbara Rose who feels that: "Not innovation, but originality, individuality and synthesis are the marks of quality in art today as they always have been."[24] Nevertheless, "being innovative" has been a major factor in our assessment of art and its development since the beginning of the nineteenth century. With the rapidly expanding possibilities of communication over the last decades, each innovation has taken on more importance and "innovations" have followed one after another and have been disseminated across the world at a constantly more rapid pace. "Being an artist" has come to be equated with "being innovative", with creating something never seen before or, more likely, creating in a way never before considered. This concept has permitted art historians to establish groups or schools of artists to be categorized and judged on the basis of the use of certain innovative practices. The idea of the "end of painting" could be interpreted as coinciding with the end of artists being able to find and develop still more innovations. Art in fact may have already reached a point of innovative exhaustion. The artistic solution to this increasingly limited horizon of innovative possibilities is being explored by artists such as Anno Frank Leven and others of his generation who somehow seek to assert individual expression through strategies such as returning to forms of art which could be called "pure painting" and including an accompanying return to "classical values".

<div align="center">* * *</div>

One of the artists whom Leven considers among his role-models is Pierre Bonnard (1867-1947). In this choice, Leven not only shows interest in returning to "pure" painting, but also points towards a return to the idea of "painterliness", a concept reflected in the

22. Heinrich Klotz: Abstraction and Fiction" in *Refigured Painting: The German Painting: 1960-1988*, Guggenheim Foundation, New York and Prestel Verlag, Munich: p. 5.
23. David Galloway "The No-Trend Decade", *Art News*, October, 1993: p. 131.
24. See: Barbara Rose *American Painting: The Eighties*, Buffalo 1979. This refers to the 1979 exhibit at the Museum of Modern Art in New York. Almost no one agrees with Rose's choice of works for this show but most would agree with her ideas at that time.

rich and vibrant colorations of his recent works.[25] Equally high on Leven's list of personal influences is Lovis Corinth (1858-1925). Corinth's chief "innovation" was to base his art unabashedly on German and French artists of the early and middle nineteenth century. In his art, Corinth also was totally self-referential and thus, although turning to the past for inspiration, his artistic orientations were still essentially contemporary. Leven and some of his fellow artists in Düsseldorf, Cologne, Wuppertal, Hamburg and elsewhere seek to follow similar paths. These are paths which would have been much less feasible even ten years ago when Germany's political and social past as well as the continuing influence of the works of earlier twentieth-century artists such as Picasso, Matisse, Kirchner, Nolde and also Corinth all were still too close in time and too dominating to allow new and uninhibited artistic creativity. [26]

Anno Frank Leven and other artists of his generation find themselves liberated from a complex and difficult political and social legacy. They are living in an exhilarating period in which they finally can freely seize upon and make use of many positive elements in their cultural heritage.[27] These young artists now have the possibility of expressing the full measure of their individual creative capacities.

R. Stanley Johnson

25. There have been other returns to "painterliness", for example with the 1945-1960 works of the *Cobras* (Alichenski, Appel, Corneille and Jorn to which group we would add the Dutch-born De Kooning) and particularly those of the early Appel.
26. See: George Kubler *The Shape of Time: Remarks on the History of Things*, New Haven and London 1962, p.8. Kubler rejects the 19th century romantic conception of genius as a "congenital disposition" and sees the phenomenon rather as a "fortuitous keying together of disposition and situation into an exceptional efficient entity". It is this sort of "fortuitous" situation which, at a given place and point in time, could facilitate the "emergence " of latent artistic talent.
27. Included here is the multifaceted concept of "a return to classical values" mentioned above. Examples could be cited such as Ingres' "return" to Raphael, Manet's inspiration in Velasquez or Cezanne's artistic references to Poussin.

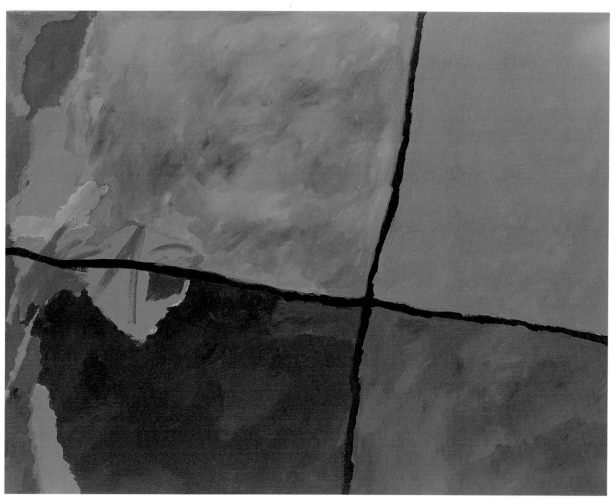

18. *Squares* (Vierecke), 1992

LEVEN ON LEVEN

From 1971 to 1978, I studied at the Düsseldorf Kunstakademie in preparing to become an art professor. At one point, after four weeks of complete seclusion in Paris in 1973, I decided to devote myself entirely to painting only. For a number of months, I lived isolated in a single sheltered hut near the little village not too far from Pian de Melosa in the region of Florence. There I began my intensive work in painting at the same time that I wrote poetry (I received the Leonce and Lena Prize for Poetry in Darmstatt in 1977). I was doing a lot of drawing and painting over these years. This was the beginning of what for me was a completely new painting from which my personal style of today developed. Influenced by Italy's strong and richly colored light, I was particularly impressed with landscape structures and began to analyse my subjects through drawing in color while using the whiteness of the canvas as a sort of in-between area. Only through distancing oneself from the canvas could one see how my abstract brushstrokes changed themselves into a recognizable corresponding landscape.

Between 1978 and 1983, I continued my painting in the tiny village of Dies in the Westerwald. At first, I painted outside in nature. Later, as I worked with larger formats in the studio, I changed over to using some landscape photographs. Gradually the structures of my paintings began to break loose from "reality" and developed into purely, abstract painting. Working in Neuss on the Rhine, between 1983 and 1985 the motives of my works again became recognizable and, in spite of the fact that I retained a painterly decomposition, larger color areas emerged in my paintings.

From 1985 to 1987, I lived in Finland with Pirkko Iisalo who now is my wife. Influenced by the light of the north, I made paintings in which the white of the backgrounds and the underlying drawing of the painting converged. After long periods of painting in the solitude of Finland, I returned to Düsseldorf. I had missed my artist friends (especially Jan Kolata, Sybille Berke, Horst Gläsker and Fernand Roda) and also the exchange of thoughts with the actuality of the contemporary art scene. Particularly after my return to Düsseldorf in 1987, my paintings distanced themselves from the exclusive depiction of landscapes from either Neuss or Finland. Aside from the different themes (people, still-lifes and others), the formal structure of my paintings had changed. My more recent paintings use a variety of color-planes. They have become more painterly and move between an abstract viewed subject and total abstraction.

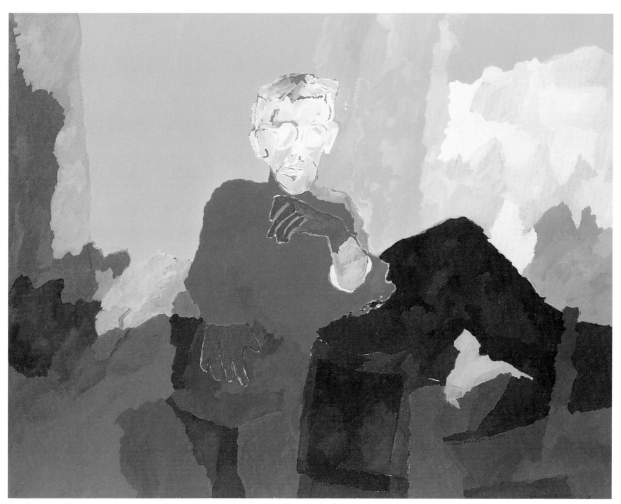

5. *Round Eyeglasses and Red Hands* (Runde Brille und rote Hände), 1989

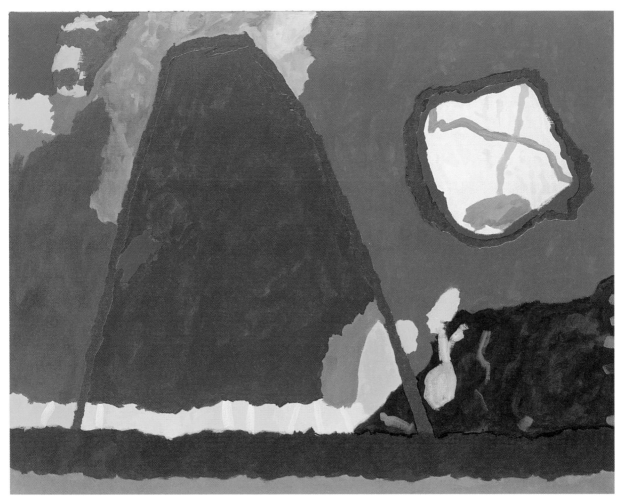

22. *Mountain-Top with Moon* (Berggipfel mit Mond), 1993

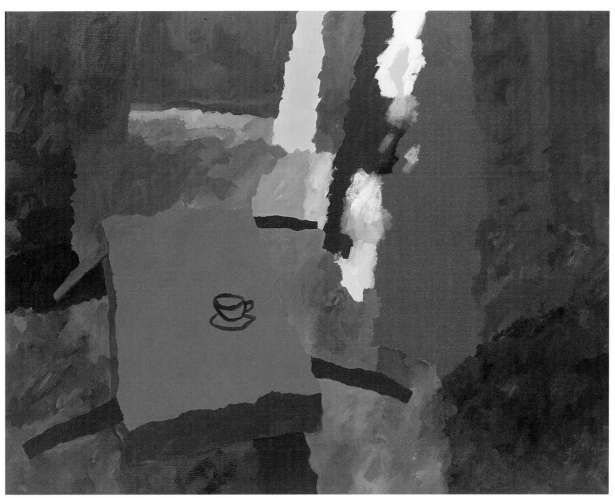

12. *The Table is Tired* (Der Tisch ist müde), 1991

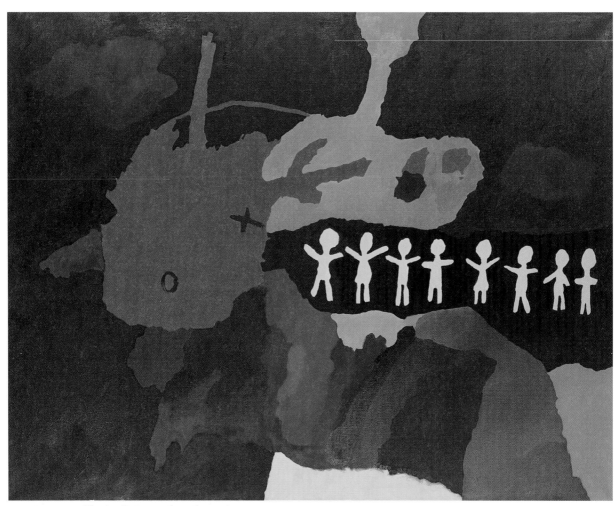

6. *Human Chain* (Menschenkette), 1990

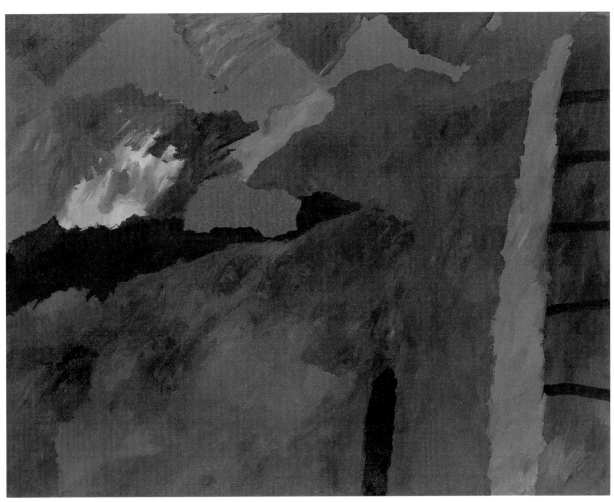

17. *On Mount Aetna* (Am Atna), 1992

Some Thoughts on the Use of Color in the Paintings of Anno Frank Leven

...Color landscape and inserted objects or figures are two elements of the art of A.F. Leven which hold each other in a state of unresolved tension. The picture as a whole does not resolve this tension. The elements of color and figuration do not melt together. On the contrary, they each try to "swallow up" the other elements of each picture. This in itself creates tension and yet, in these back and forth movements, there remains an undivided unity in each painting. Tension emerges and yet overall there is a great calmness.

A.F. Leven's images are spaces built out of colors and sparsely furnished with associative objects and figurative indications. Once the eye has become adjusted to the particular "construction" of these images, one sees interiors and landscapes. One sees what the title precisely means or indicates through association: a lake, a river with a bridge, a corner in a room, a restaurant's interior.

Colors in A.F. Leven's images have clearly noticable limits. In contrast to the interspersed objects and, with reservations, also in contrast to the figures, they have no contours. The colors are outlined by their contrasts; they mix only where nuances of white are required. First of all, color is equated with intensity - islands in an ocean of feelings or moving waters along a coastal line of temperaments. The colors do not affirm the world which is built into these images, but they make it inhabitable. In A.F. Leven's pictures, space is created through the arrangement of the color fields. They diminish perspectively towards the middle or the background of a picture; parallel color bands pile up until through a suggestive shaping, a massive mountain, a sky or a forest become recognizable; an object or a figure brings the colors into an experience of space.

Heinz Thiel
From the introduction to
Anno Frank Leven,
Düsseldorf, 1990

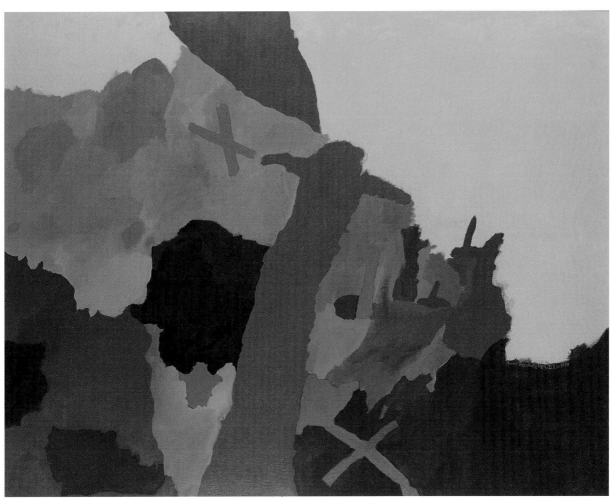

7. *Hidden Finland* (Verstecktes Finnland), 1990

BIOGRAPHIC NOTES

Anno Frank Leven

1948	Born in Krefeld-Uerdingen, Germany
1971-78	Studied painting in Düsseldorf's Staatlichen Kunstakedemie where Paul Klee and more recently Josef Beuys had taught.
1977	Won the Leonce and Lena Prize for New Poetry. Various poetry readings.
1975-78	Long study séjours in Tosi-Pian di Melosa near Florence.
1978-83	Painted long months in the countryside of Dies/Westerwald. Traveled in U.S.A.
1984	Long period spent in Finland, the country of his wife.
1985	Summer studio in Viitasaari/Middle Finland. Winter in Helsinki.
1986	Travels to St. Petersburg and Tallin in Russia.
1987	Travels to Norway, Hungary, Czechoslovakia and Portugal. Studios in Düsseldorf and Helsinki.
1989	Receives the Rhein-Sieg Prize for Painting.
1991	Documentary film (45 minutes) on television: *Anno und Pirkko* (Pirkko is Leven's Finnish wife)

Personal Exhibits

1978	Down and Upstairs, Recklinghausen
1980	Zürich-Haus, Düsseldorf
1982	Galerie Wolff, Düsseldorf
1983	Galerie Linssen, Bonn; Galerie Keller-Holk, Rheda
1984	Galerie Linssen, Bonn
1985	Galerie Viitasaari, Finland
1986	Galleria Bronda, Helsinki
1987	Malerei und Architektur, Jürgensplatz, Düsseldorf
1989	Galeire Lipski, Wesel; Galerie Artforum, Hannover
1990	Galerie Forum Bilkerstrasse, Düsseldorf; Galerie Hoenisch, Gros-Umstadt; Galerie Ilverich, Meerbusch/Düsseldorf
1991	Galerie Hagener Kunstkabinett, Hagen
1992	Galerie Ilverich, Meerbusch/Düsseldorf

Group Exhibits

1979	Forum junger Kunst, Stuttgarter Kunstgebäude
1979-81	Ausstellung zum Kunstpreis des Rhein-Sieg-Kreises, Siegburg
1982	Fön, Kunst Fabrik Lothringer Strasse, Munich
1983	Galerie Wolff-Klaus, Düsseldorf; Internationaler Kunstmarkt, Cologne; Galerie Linssen, Bonn
1984	Galerie Keller-Holk, Rheda-Wiedenbrück
1985	Westdentscher Künstlerbund, Karl-Ernst-Osthaus-Museum, Hagen
1986	Galleria Bronda, Helsinki
1987	Galerie Zimmer, Düsseldorf; Auran Galleria, Turku, Finland; Galleria Bronda, Helsinki
1988	Meine Zeit, mein Raubtier ("My Time, My Preying Animal"), Kunstmuseum, Düsseldorf
1989	Galerie Kadenz, Geldern
1990	Galerie Artforum, Hannover; Trinkhaus Bank, Düsseldorf; Galerie Ilverich, Meerbusch/Düsseldorf; Grosse Düsseldorfer Kunstausstellung, Kunstpalast
1991	Summer Exhibition, Pyhäniemi, Finland; Grosse Düsseldorfer Kunstausstellung, Kunstpalast
1992	Grosse Düsseldorfer Kunstausstellung, Kunstpalast

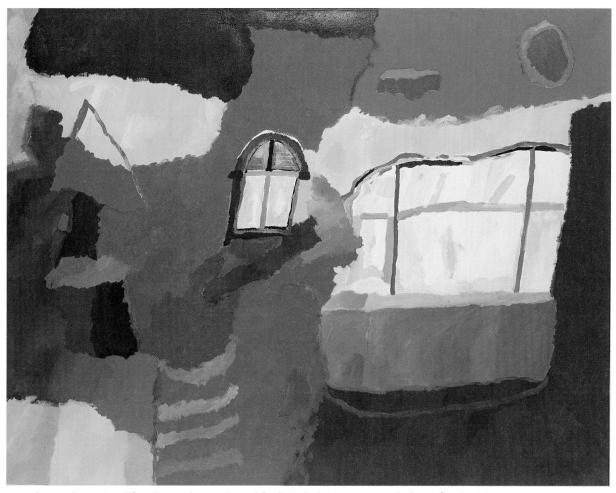

13. *Sometimes Inside, Sometimes Outside* (Mal drinnen, mal draußen), 1991

SELECTED BIBLIOGRAPHY

Buchloh, Benjamin H. D.: *Figures of Authority, Ciphers of Regression: Notes on the Return of Representation in European Painting;* in: *OCTOBER* , no. 16 (Spring 1981).

Bilderwechsel, Neue Malerei aus Deutschland; Berlin, Frölich & Kaufmann, 1981.

Binationale, German Art of the late 80s, American Art ot the late 80s, (Boston- Düsseldorf); Contributing essays by Jürgen Harten, Jürg Altwegg, Dietmar Kamper, Rainer Crone, Ulrich Luckhardt, Jiri Svestka; Cologne, Du Mont, 1988

Celant, Germano: *The European Iceberg: Creativity in Germany and Italy today;* Milan, Rizzoli, 1985, Art Gallery of Ontario, Toronto, 1985.

Cowart, Jack, Ed.: *Expressions: New Art from Germany,* The Saint Louis Art Museum, 1983.

Crimp, Douglas: *The End of Painting;* in: *OCTOBER,* no. 16 (Spring 1981).

German Art Now; Contributing essays by Heinrich Klotz, Demosthenes Davvetas, Andreas Franzke, Andrew Benjamin, Benjamin H.D. Buchloh, Irit Rogoff, Michael Govan, Walter Grasskamp, David Galloway, Paul Crowther, Regina Lindenau, Markus Lüpertz, Gerhard Richter; London, New York, St. Martin's Press, 1989.

Gohr, Siegfried: *The Difficulties of German Painting with its own Tradition;* in: *Expressions: New Art From Germany,* The Saint Louis Art Museum, 1983.

Govan, Michael: *Meditation on A=B: Romanticism and Objectivity in the new German Painting;* in: *New Figuration, German Painting 1960-88;* New York, The Soloman R. Guggenheim Foundation, 1989; Munich, Prestle, 1989.

Herbstsalon: Zwölf Künstler lassen noch viel erwarten; in: *ART;* pp 68, Hamburg, October 1993.

Klotz, Heinrich: *Abstraction and Fiction;* in: *New Figuration, German Painting 1960-88* ; New York The Solomon R. Guggenheim Foundation,1989; Munich, Prestle, 1989

Krens, Thomas: *German Painting: Paradox and Paradigma in the Art of the late 20th Century;* in: *New Figuration, German Painting 1960-88;* New York, The Soloman R. Guggenheim Foundation, 1989; Munich ,Prestle, 1989

Kubler, *George: The Shape of Time;* New Haven, Yale University Press, 1962.

Kuspit, Donald B.: *Flak from the "Radicals"; The American case against current German Painting* in: *Expressions, New Art from Germany;* The Saint Louis Art Museum, 1987.

Lawson, Thomas: *Last Exit: Painting* ; in: *ART FORUM,* October,1981.

A.R. Penck: *Im Gespräch mit Wilfried Dickoff;* Köln, Kiepenheuer & Witsch, 1990.

Schulz-Hoffmann, Carla: "Nero malt" oder "Eine neue Apotheose der Malerei", in: *Deutsche Kunst Seit 1960; (Sammlung Prinz Franz von Bayern)* , Munich, Prestle 1985.

Schuster, Peter-Klaus: "Das Ende Des 20. Jahrhunderts"- Beuys, Düsseldorf und Deutschland ; in: *Deutsche Kunst seit 1960;(Sammlung Prinz Franz von Bayern,);* Munich, Prestle, 1985.

Thiel, Heinz; Bartosz, Andreas: *Anno Frank Leven: Bilder;* (Forum Bilker Str.); Düsseldorf, Kulturamt,1990.

Thompson, Joseph: *We Call it Blasphemie! The Fate of the Figure in German Art after the War;* in: *New Figuration, German Painting 1960-88;* NewYork, The Solomon R.Guggenheim Foundation 1989; Munich, Prestle, 1989.

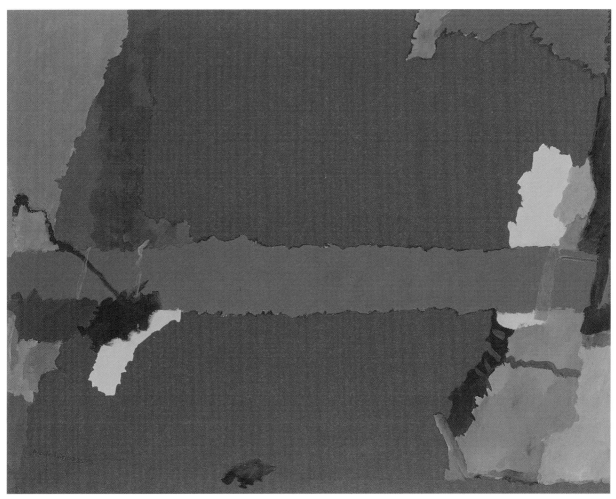

27. *Disengagement* (Abtrennung), 1993

CATALOG

PAINTINGS

1. *Kirmes*, August 24, 1988
 Kermess: Fair
 Oil on canvas
 100 x 130 cm., 39 1/2 x 51 1/2 in.
 Signed and dated D. 24.08.88

2. *Vier Bäume am Dorfweiher*, October 25, 1988
 Four Trees at the Village Pond
 Oil on canvas
 140 x 180 cm., 55 1/4 x 71 in.
 Signed and dated D. 25.10.88

3. *Mann in der Ecke*, November 17, 1988
 Man in the Corner
 Oil on canvas
 125 x 155 cm., 49 1/2 x 61 in.
 Signed and dated D. 17.11.88
 Exhibited:
 Anno Frank Leven: Bilder
 Forum Gallery, Dusseldorf, 1990:
 reproduced in color in catalog.

4. *Drachenpflanze und Kohleofen,,*December
 5, 1988
 Dragonplant and Coal Stove
 Oil on canvas
 110 x 140 cm., 43 1/2 x 55 1/4 in.
 Signed and dated D. 05.12.88
 Exhibited:
 Anno Frank Leven: Bilder
 Forum Gallery, Düsseldorf,1990:
 reproduced in color in catalog.

5. *Runde Brille und roteHände*, August 30, 1989
 Round Eyeglasses and Red Hands
 Oil on canvas
 140 x 180 cm, 55 1/4 x 71 in.
 Signed and dated D. 26.08.89
 Exhibited:
 Anno Frank Leven: Bilder
 Forum Gallery, Dusseldorf, 1990:
 reproduced in color catalog.

6. *Human chain*
 Menschenkette, September 30, 1990
 Oil on canvas
 140 x 180 cm, 55 1/4 x 71 in.
 Signed and dated D. 30.08.89

7. *Verstecktes Finnland*, October 5, 1990
 Hidden Finland
 Oil on canvas
 140 x 180 cm., 55 1/4 x 71 in.
 Signed and dated D. 05.10.90

8. *Auf dem Finnjet nach Travemünde*
 October 28, 1990
 On the Finn Jet to Travemünde
 Oil on canvas
 60 x 80 cm, 23 3/4 x31 1/2 in.
 Signed and dated . 28.1.90

9. *Ein Tisch und zwei Stühle*, February 6, 1991
 One Table andTwo Chairs
 Oil on canvas
 60 x 70 cm, 23 3/ x 27 1/2 in.
 Signed anddated D. 06.02.91

10. *Eisbecher mit Säule*, February 13, 1991
 Icebreaker with Column
 Oil on canvas
 60 x 70 cm, 23 3/4 x 27 1/2 in.
 Signed and dated D. 13. 02.91

11. *Grauer Himmel und roter Streifen*
 April 12, 1991
 Grey Sky and Red Stripe
 Oil on canvas
 70 x 90 cm, 27 1/2 x 35 1/2 in.
 Signed and dated D. 12.04.91

12. *Der Tisch ist müde*, August 16, 1991
 The Table is Tired
 Oil on canvas
 100 x 130 cm., 39 1/2 x 51 in.
 Signed and dated D.

13. *Mal drinnen, mal draußen*, September 20, 1991
 Sometimes inside, sometimes outside
 Oil on canvas
 130 x 170 cm., 51 1/4 x 67 in.
 Signed and dated: D. 20.09.91

14. *Die Erscheinung*, January 3, 1992
 The Apparition
 Oil on canvas
 100 x 130 cm., 39 1/2 x 51 1/4 in.
 Signed and dated, D. 03.01.92

15. *Die violette Linie*, January 30, 1992
 The purple Line
 Oil on canvas
 70 x 90 cm., 35 1/2 x 27 3/4 in.
 Signed and dated: D. 30.01.92

16. *Einer steht und einer liegt*, March 26, 1992
 One Stands Up and One Lies Down
 Oil on canvas
 100 x 130 cm., 39 1/2 x 51 1/4 in.
 Signed and dated,:D. 26.03.1992

17. *Am Atna*, May 27, 1992
On Mount Aetna
Oil on canvas
100 x 130 cm., 39 1/2 x 51 1/4 in.
Signed and dated: D. 27.05.92

18. *Vierecke*, July 10, 1992
Squares
Oil on canvas
100 x 130 cm., 39 1/2 x 51 1/4 in.
Signed and dated: D. 10.07.92

19. *Ohne Titel*, October 7, 1992
Without a Title
Oil on canvas
60 x 80 cm, 23 3/4 x 31 1/2 in.
Signed and dated: D.07.10.92

20. *Ohne Titel*, November 12, 1992
Without a Title
Oil on linen
60 x 80 cm. 23 3/4 x 31. 1/2 in.
Signed and dated: D. 07.10.92

21. *Abtrennung*, May 3, 1993
Disengagement
Oil on canvas
100 x 130 cm., 39 1/2 x 51 1/4 in.
Signed and dated: D. 03.05.93

22. *Berggipfel mit Mond*, May 17, 1993
Mountaintop with Moon
Oil on canvas
100 x 130 cm., 39 1/2 x 51 1/2 in.
Signed and dated: D. 17.05.93

23. *Schwarzfeld*, September 18, 1993
Black Field
Oil on canvas
60 x 80 cm., 23 3/4 x 31 1/2 in.
Signed and dated: D. 18.09.93

WORKS ON PAPER

24. *Das Atelier in Helsinki*, April 28, 1988
The Atelier in Helsinki
Tempera on paper
60 x 75 cm., 23 5/8 x 29 1/2 in.
Signed and dated: D.28.04.88

25. *Am Wasserfall*, May 3, 1989
At the Waterfall
50 x 65 cm., 19 3/4 x 25 1/2 in.
Acrylic on paper
Signed and dated: D.03.05.89

26. *Das Weisse Eckhaus*, June 11, 1990
The White House at the Corner
Tempera on paper
60 x 80 cm., 23 5/8 31 1/2 in.
Signed and dated: D.11.06.90

27. *Die Billardtische*, September 21, 1990
The Billiard Tables
Tempera on paper
55 x 71 cm.k 21 1/2 x 28 in.
Signed and dated: D. 21.09.90

28. *Blaue Zypressen*, December 11, 1992
Blue Cypresses
Tempera Acrylic on paper
70 x 90 cm., 27 1/2 x 35 1/2 in.
Signed and dated: D. 11.12.92

29. *Ohne Titel*, December 19, 1992
Untitled
Tempera and Acrylic on paper
70 x 90 cm., 27 1/2 x 35 1/2 in.
Signed and dated: D. 19.12.92

30. *Ohne Titel*, Janurary 27, 1993
Untitled
Tempera and Acrylic on paper
96 x 109.5 cm., 38 1/4 x 43 in.
Signed and dated: D.27.01.93

31. *Ohne Titel*, Febuary 14, 1993
Untitled
Tempera on paper
87 x 104 cm., 34 1/4 x 40 7/8 in.
Signed and dated: D.14.02.93

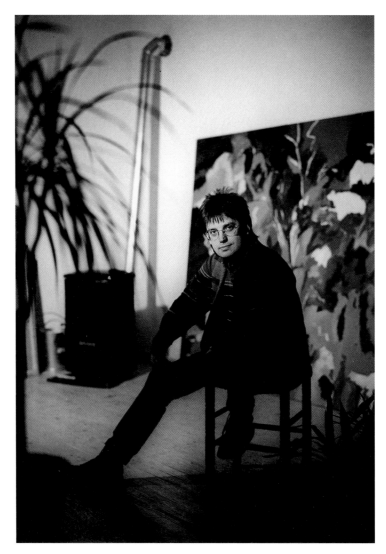

Anno Frank Leven in his Atelier
(Photo: Markus Rössle, Düsseldorf/Vienna)

Silence

Silence crosses my little village street.
She does not look at me,
and I do not try to catch her glance.
She crosses the market place and
turns right, down a sentinel.
I lean on the lattice of the balcony.
After some time
I go back into the house.

A. F. L.

MUSEUM ACQUISITIONS
from
R.S. JOHNSON FINE ART

University of Texas - Austin
Baltimore Museum of Art - Baltimore
Birmingham Museum of Art - Alabama
Indiana University of Art Museum - Bloomington
Museum of Fine Arts - Boston
Krannert Art Museum (U. of Illinois) - Champaign
Art Institute of Chicago - Chicago
Smart Museum of Art (U. of Chicago) - Chicago
Terra Museum of American Art - Chicago
Cleveland Museum of Art - Cleveland
Museum of Art & Archaeology -Columbia, Missouri
Des Moines Art Center - Iowa
Detroit Institute of Art - Detroit
Amon Carter Museum - Fort Worth
Musée du Petit Palais - Geneva (Switzerland)
The Houston Museum of Fine Art - Houston
Indianapolis Museum of Art - Indianapolis
Middlebury College Museum of Art - Middlebury
Milwaukee Art Museum - Milwaukee
Lutheran Brotherhood Museum - Minneapolis
Yale University Art Gallery - New Haven
Ball State University Art Gallery - Indiana
The Metropolitan Museum of Art - New York
Owensboro Museum of Art - Kentucky
Pasadena Art Museum - California
La Salle College Gallery of Art - Philadelphia
McNay Art Institute - San Antonio
St. Louis Art Museum - St. Louis
The Toledo Museum of Art - Toledo
Tucson Museum of Art - Tucson
National Gallery of Art - Washington D.C.
National Museum of American Art - Washington D.C.